Tattoo Artist

ODD JOBS

VIRGINIA LOH-HAGAN

 45th Parallel Press

Published in the United States of America by Cherry Lake Publishing
Ann Arbor, Michigan
www.cherrylakepublishing.com

Content Adviser: Rob Lloyd, tattooer, The Black Rose, Waterford MI
Reading Adviser: Marla Conn, ReadAbility, Inc.
Book Design: Felicia Macheske

Photo Credits: © Ronald Sumners / Shutterstock.com, cover, 1; © Bill Putnam / ZUMAPRESS / Newscom, 5;
© Rob Lloyd / The Black Rose, 6; © Mikhail_Kayl / Shutterstock.com, 9; © jacomstephens / iStock, 11; © Todor
Rusinov / Shutterstock.com, 13; © Everett Historical / Shutterstock.com, 15; © Pavel L Photo and Video /
Shutterstock.com, 16-17; © LukaTDB / Shutterstock.com, 19; © Heritage Image Partnership Ltd / Alamy, 21;
© Todor Rusinov / Shutterstock.com, 23; © Chronicle / Alamy, 25; © Ron Chapple studios / Thinkstock, 27;
© Zoonar RF / Thinkstock, 28; © ARENA Creative / Shutterstock.com, cover and multiple interior pages;
© oculo / Shutterstock.com, multiple interior pages; © Denniro / Shutterstock.com, multiple interior pages;
© PhotoHouse / Shutterstock.com, multiple interior pages; © Miloje / Shutterstock.com, multiple interior pages

45th Parallel Press is an imprint of Cherry Lake Publishing.

Library of Congress Cataloging-in-Publication Data

Loh-Hagan, Virginia.
 Tattoo artist / Virginia Loh-Hagan.
 pages cm — (Odd jobs)
 Includes bibliographical references and index.
 ISBN 978-1-63470-031-3 (hardcover) — ISBN 978-1-63470-085-6 (pdf) — ISBN 978-1-63470-058-0 (pbk.)
— ISBN 978-1-63470-112-9 (ebook)
1. Tattoo artists. 2. Tattooing. I. Title.

 GT2345.L65 2016
 391.6'5—dc23

 2015008292

Cherry Lake Publishing would like to acknowledge the work of The Partnership for 21st Century Skills.
Please visit www.p21.org for more information.

Printed in the United States of America
Corporate Graphics Inc.

Contents

Helping Hands

Why do people get tattoos? Why do soldiers get tattoos? How do tattoo artists help people?

People get **tattoos** for different reasons. Tattoos are designs on skin. They last a long time. Tattoo artists give tattoos to people.

Aki Paylor is a soldier. His tattoos make him stand out. He said, "Every tattoo I have on my body says something about who I am, where I'm from, or the things I've been through."

Tattoos make him proud. Paylor said, "The army is not just a job. It's a way of life."

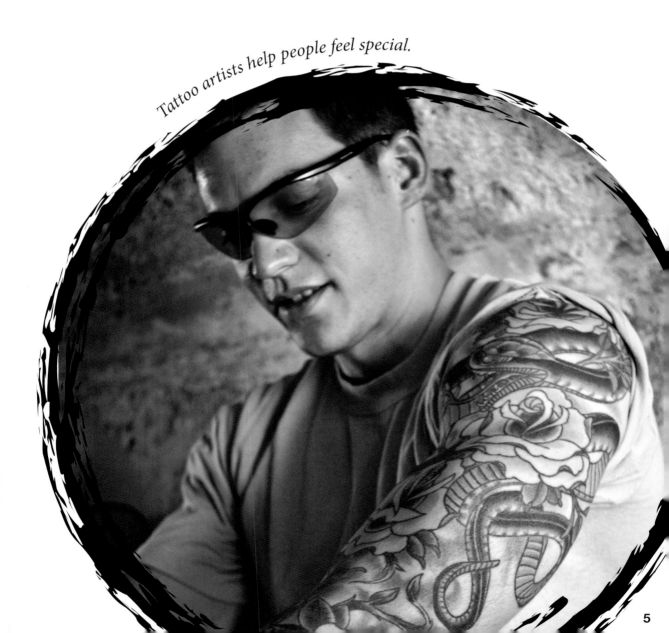

Tattoo artists help people feel special.

Tedd Hucks is a tattoo artist. Keith Anderson has a son named Kai. Hucks tattoos Kai's drawings on Anderson. Anderson and Kai choose a drawing. They do this each year. They enjoy talking about each tattoo.

*Tattoo artists help create personal and **permanent** art.*

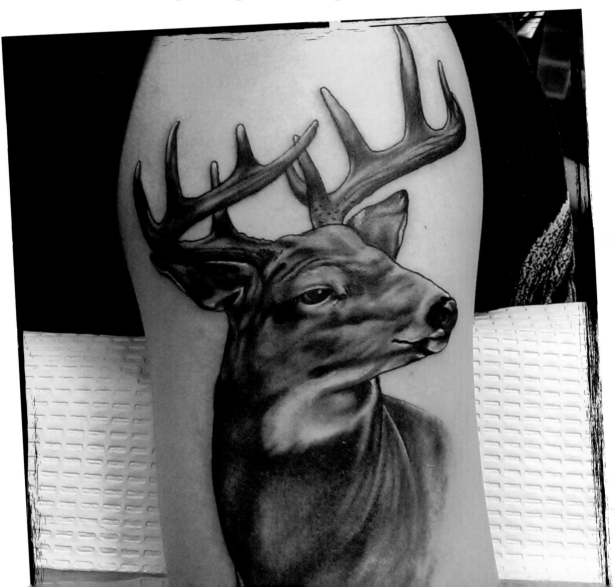

BASMA HAMEED

Basma Hameed is a paramedical tattoo specialist. She's from Iraq. She was burned by hot oil. It was in a kitchen accident. She was two years old. She had more than 100 procedures. She wanted to hide her burns. Parts of her face were scarred and discolored. She had eyebrows permanently tattooed on. This gave her an idea. She learned how to tattoo. Hameed said, "I did a lot of research, and of course I went to school." She tattooed her own face to hide the burns. She opened up clinics. She helps people like Samira Omar. Omar was beaten. Bullies poured boiling water on her. Her forehead lost color. The back of her neck was scarred. Hameed felt connected to Omar. Hameed helped hide Omar's scars with tattoos. She increased her confidence.

Anderson said, "I love when he is proud of his work and asks me to roll up my sleeve and show it off."

Hucks lets Kai help. Kai told his teacher, "I tattooed my dad!" Tattoo artists help create art. They help save memories.

Some tattoos cause bad memories. Tattoo artists remove these tattoos. This helps people. They can cover up tattoos.

Gang members get tattoos. This shows they belong to a gang. Some members quit their gangs. But their tattoos still scare people. Tattoo artists fix gang tattoos. They help old gang members start new lives.

Some people use violence to tattoo other people. The people don't want these marks. Chris Baker is a tattoo artist. Baker wants people to feel better. He wants to take away the bad memories. He covers tattoos people don't want.

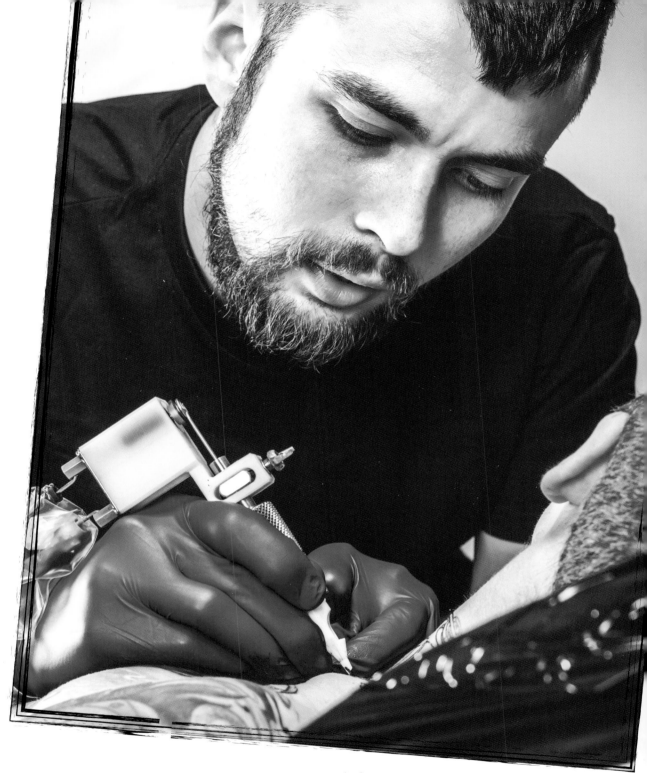

Tattoo artists help give people a second chance.

CHAPTER 2

Making Skin Art

What do tattoo artists do? What do tattoo artists learn about their clients? How do tattoo artists tattoo? What tools do tattoo artists use?

Tattoo artists do more than draw. They learn about their **clients**. Clients are people who get tattoos. Tattoo artists make sure clients are old enough. They make sure clients are healthy. They clean the area. They shave the area.

Clients choose designs. Tattoo artists make an outline on the skin. Outline means there is no inside.

Then, they fill in the tattoo. They use different colors. They shade it in different ways.

Tattoo artists inject **pigments**. Pigments are color found in ink. They use needles. They dip the needle in ink. They poke the skin. They draw a little bit at a time. They wipe the area. They repeat.

Tattoo artists provide many designs for people to see. They can also create special designs for people.

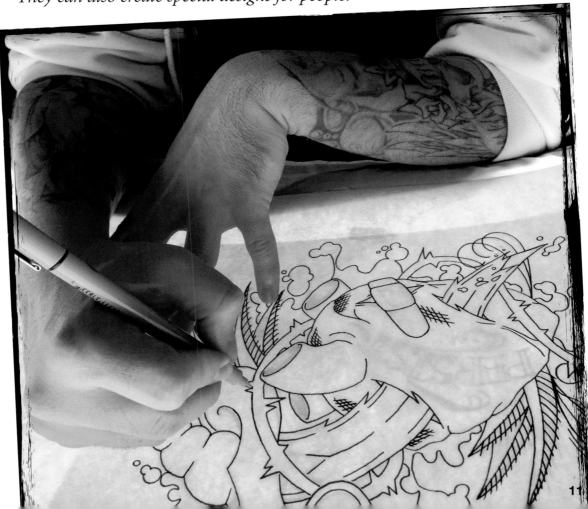

Advice From the Field
BRAD STEVENS

Brad Stevens copied tattoo artists from the past and present. He learned from them. Then, he created his own style. He said, "The more I followed the trends of the time, the more dated the tattoos ended up being. That's when I started to strip down my style and tried to give my tattoos a more timeless look." He advises against lettering. He said, "It fights the organic shape of the body, ages terribly, and loses its impact if you have to look at it every day." Stevens likes folk art and traditional tattoos. These images look clean and simple. He advises, "Traditional American and Japanese designs work great for tattoos because they are the product of years and years of trial and error." Tattoo artists should pay attention to what works best for the body.

Tattoo artists use a tattoo machine. The needles come in different shapes. They make lines. They're used to shade. Tubes hold the ink. Inks are placed in tiny cups. The motor is run by electricity. A foot pedal controls the movement.

Artists clean the needles with water. This is done during the tattooing. It's also done during color changes.

Some tattoo artists use a stencil machine. It uses special paper. Tattoo artists put the special paper on the skin. The design comes off the paper. It sticks to the skin.

Tattoos are open cuts. Tattoo artists tell clients to be careful. They clean the area. They give clients bandages. They give them healing cream.

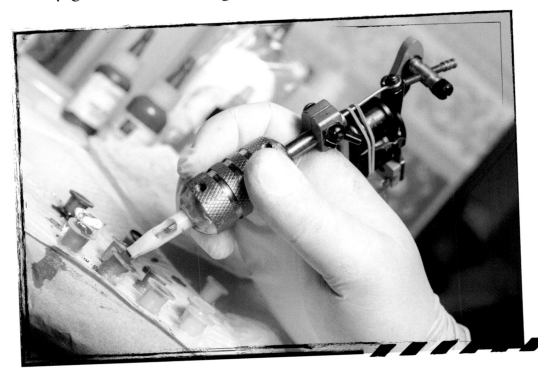

Magnums are needles used for coloring and shading.

CHAPTER 3

To Be Ink Masters

Who is Charles Wagner? Why do people want to become tattoo artists? What are some things tattoo artists specialize in? What do people need to do in order to become a tattoo artist?

Charles Wagner was an early American tattoo artist. He helped develop tattooing. He changed how people looked. He tattooed women's lips, cheeks, and eyebrows. He also tattooed horses and dogs. This was so they couldn't be stolen.

Wagner was inspired by Prince Constantine. Prince Constantine was a famous tattooed man. Wagner said, "He was covered right up to the eyeballs with animals. … I borrowed some ink and a needle and started tattooing myself." This started his love for tattooing.

Many people feel that tattooing is an art. The body is the canvas.

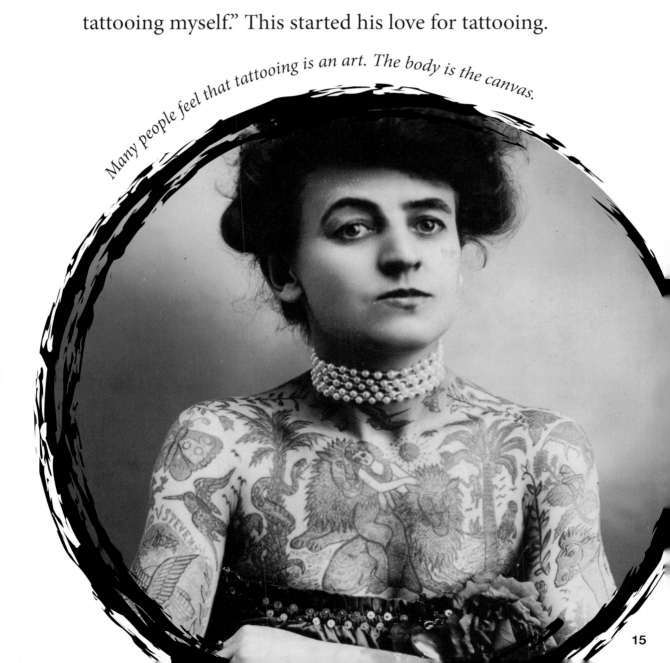

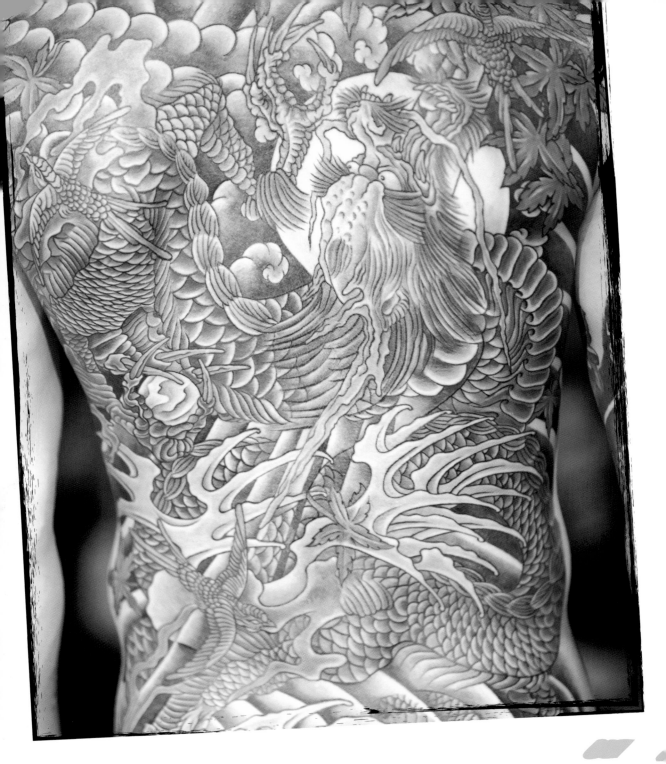

Tattoo artists get very good at tattooing certain styles.

The art of tattoos inspires people. Some want to become tattoo artists. Many tattoo artists start as clients. They get hooked.

Tattoo artists are experts on different styles. Some tattoo artists are good at drawing **portraits**. This is the drawing of faces. Some are good at drawing letters.

Jesse Smith is inspired by **graffiti**. Graffiti is a type of art. It's scribbled on public places. His designs are like cartoons.

Ty'Esha Reels makes color tattoos.

Heather Sinn's tattoos look like actual paintings.

Amanda Wachob's tattoos are like paintings. The colors drip. The colors blend.

Tattoo artists are good artists. They practice their art.

WHEN ODD IS TOO ODD!

Some people tattoo their eyeballs. Luna Cobra created this type of tattooing. Cobra wanted to look like a character from *Dune*. *Dune* is a science-fiction movie. A needle is inserted into the eyeball. Pigment is injected. It rests under the eye's thin top layer. People color their eyeballs blue, green, red, or black. Cobra said, "I'm aware of how insane that sounds. I think it brings a realm of fantasy into everyday life." Not everyone agrees with this "extreme tattooing." People could suffer damage or blindness. Cobra said, "It's shocking. We had no idea anyone else would do it. And now everyone's obsessed with it. It's a shame because I think it's something really beautiful, but it's taken an odd course."

Tattoo artists learn from older tattoo artists. They work in **studios**. Studios are tattoo shops. They do this for about two years. They learn about safety. They learn what to do with blood. They learn how to be clean. They learn to use the tools. They learn to tattoo. They practice on objects. They tattoo fake skin, fruit, and leather.

Different states have different rules. Tattoo studios need to be clean. Tattoo artists may need to take tests.

Tattoo artists work in studios. They need to follow state rules.

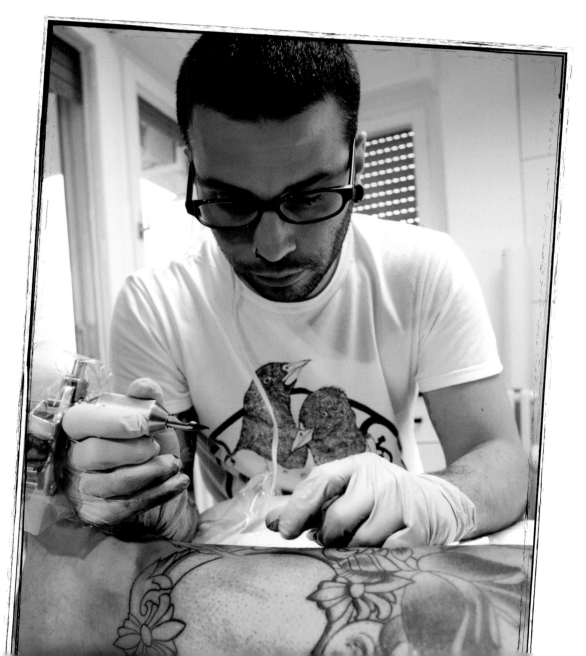

From Mummies to Modern Day

What is the origin of the word tattoo? How did the Pacific Islanders tattoo? How did tattooing develop? How did the circus help the tattooing business?

Otzi the Iceman is a **mummy**. A mummy has been **preserved** for many years. Preserved means saved. Otzi is more than 5,000 years old. He was found in Europe. He had many tattoos. The tattoos were dots and lines. Tattooing has been around for a long time.

Ancient Egyptians also tattooed. Amunet's mummy had lines on her arms and legs. An oval was on her stomach.

South American mummies had fancy designs. North African mummies had the first tattoos of pictures. Males had tattoos of war gods. Females had tattoos of Bes. Bes is the god of mothers.

The tools used to tattoo Otzi were different from today's tattoo machine. A clay disk contained charcoal used for color. The needles were made from bone.

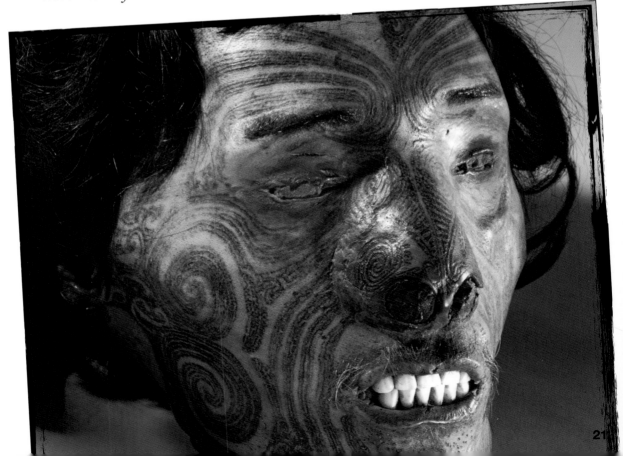

Tattoo Artist
KNOW THE LINGO!

Body suit: full body tattoo from neck to ankles, but not feet or hands

Cadaver: a client who doesn't talk during the tattooing

Carving: a term for outlining a tattoo

Custom tattoo: art that is specially designed

Flash or stock tattoo: art that is already created, usually featured on the wall

Human larvae: children running around a tattoo studio

Ink: tattoo

Meat: a regular client who has a fresh tattoo that needs to heal

Scratcher: a bad tattoo artist who tattoos from home

Showcase: a client who wears a lot of the tattoo artist's work

Sleeve: tattoos all over someone's arm or leg

Tatted: getting tattoos, having tattoos

Tight: great work

Wrastler: a client who faints and comes up fighting

Captain James Cook was an explorer. He saw tattooed people on islands in 1769. Cook introduced the word tattoo. It comes from the South Pacific word tatau. It means "to mark."

People used sharp pieces of bone or shell. This was their needle. They dipped it in ink. Ink was dust made from burning nuts. They hit the needle. They used a small hammer. This pushed the ink into the skin. They covered their whole bodies with tattoos.

Sailors were travelers. They got tattoos. They started tattooing in the United States and Europe.

One of the first American tattoo artists was C. H. Fellowes. He followed the ships. He tattooed on ships. He tattooed in **ports**. Ports are places where ships stop.

Modern tools have made tattooing quicker, easier, cleaner, and less painful.

Martin Hildebrandt opened the first American tattoo studio. He did this in New York City. He tattooed by hand. He dipped the needles in ink. His hand moved up and down. He pricked the skin. He did this two times per second. This was a slow process.

Circuses helped the tattooing business. Circuses hired people tattooed from head to toe. They shared how they got tattooed. Some stories were real. Some weren't. Many tattoo artists traveled with circuses.

George Burchett was the first tattoo artist star. He tattooed Horace Ridler. Burchett spent 150 hours tattooing Ridler. He tattooed a pattern of curved black stripes. He tattooed his face.

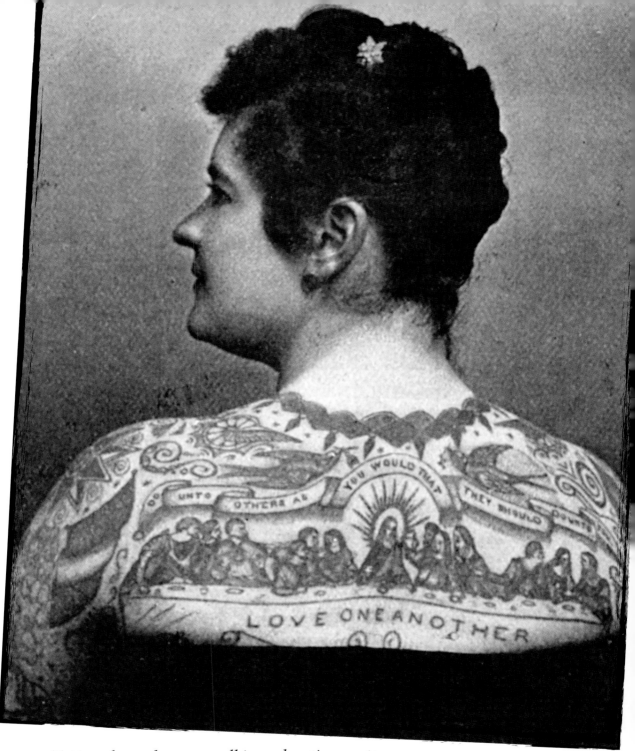

Tattooed people were walking advertisements.
They showed off the tattoo artist's art.

CHAPTER 5

Risky Business

What are the risks associated with tattooing? How do tattoo artists stay safe? Why can't tattoo artists make mistakes?

Tattoo artists create art on skin. There are risks. Using needles means there's blood. Blood can be dangerous. Blood can spread sicknesses.

Tattoo artists can get illnesses. They have to be safe. They wear gloves. They wear masks. They wash their hands. They clean their tools. They throw away dirty things.

Tattoo artists make sure their studios and tools are clean and safe.

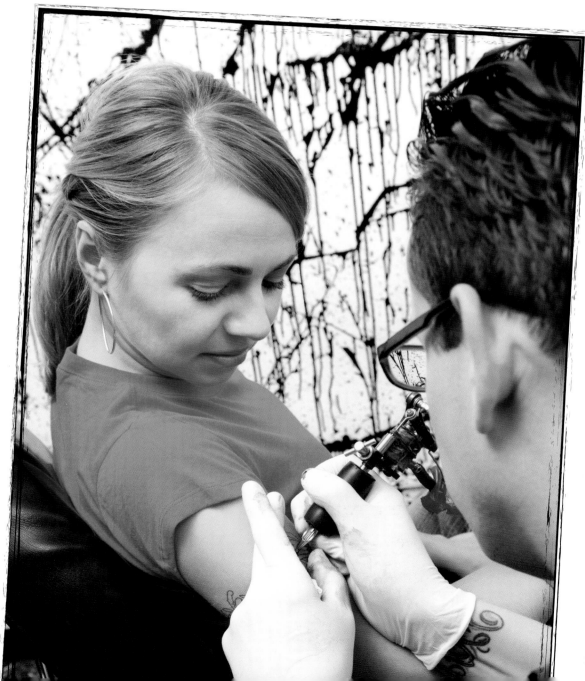

Tattoo artists can't make mistakes. Mistakes are forever. Clients may sue. This causes stress. So tattoo artists need to be sure and steady.

Tattoo artists have an odd job. But it's a rewarding job. They get to make art.

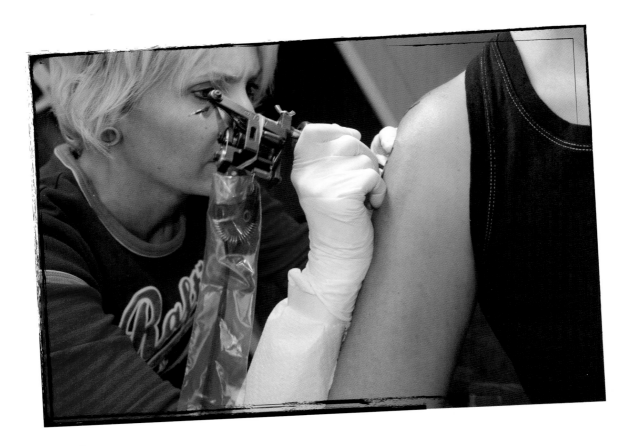

Getting a tattoo is putting permanent art on your body.

THAT HAPPENED?!?

Some people's tattoos live longer than they did. The Wellcome Collection is 300 preserved tattooed human skins. The skins are in a London museum. A French military doctor collected them. They're from the bodies of dead French soldiers. There are other collections in Japan and Poland. Preserving tattoos is not new. But leaving tattoos to family is a new idea. Henk Schiffmacher is a tattoo artist. He said, "I want to leave a few pieces of my skin behind." People keep locks of hair. They keep human ashes. Schiffmacher wants his loved ones to keep his tattoos. Doctors remove the tattooed skin. They treat the skin. They take out water and fat. They inject chemicals. They turn the skin into plastic. Then, the tattooed skin is framed.

DID YOU KNOW?

- The Great Omi was a famous tattooed man. He filed his teeth down to sharp points. He pierced his nose. He inserted an ivory tusk. He pierced his ears. He stretched the holes. George Burchett was his tattoo artist. Burchett said, "I began one of the most difficult tasks I have ever undertaken, to turn a human being into a zebra."

- Army Regulation 670-1 describes rules for how soldiers should look. New soldiers can't have more than four tattoos below the elbow or knee. They can't get tattoos on their necks, faces, heads, hands, wrists, or fingers. Tattoos must be smaller than their hands. Tattoos can't be grouped together to look like one big tattoo.

- Oliver Peck is a judge on *Ink Master*. It's a reality TV show about tattoo artists. In 2008, he set a record. He completed 415 tattoos of the number 13 in a 24-hour period.

- Tattoos age with bodies. Skin constantly replaces itself. Skin wrinkles. Tattoos eventually blur. Words become harder to read.

- Keith McCurdy is known as "Bang Bang." He's a tattoo artist for celebrities. He has tattooed Rihanna, Katy Perry, Justin Bieber, and many others. He asks celebrities to tattoo him back. They permanently autograph his leg. He said, "It's like my scrapbook."

- The Ancient Greeks and Romans tattooed their slaves, criminals, and hired soldiers. This was so they could be identified if they escaped.

- Caligula was a Roman emperor. He had members of his court tattooed. He did this to entertain himself.

CONSIDER THIS!

TAKE A POSITION! Some people see tattoos as works of art. Other people see tattoos as unprofessional. To get some jobs, tattooed people have to hide their tattoos. Do you think tattoos are artistic or unprofessional? Argue your position with reasons and evidence.

SAY WHAT? Tattooing has been practiced throughout history. It's been practiced across cultures. There are different reasons for tattooing. People tattoo for religious reasons. They tattoo for cultural reasons. They tattoo for beauty reasons. Learn about tattooing in two cultural groups. Explain how each group practices tattooing. Explain the similarities and differences between the two groups.

THINK ABOUT IT! Soldiers and sailors seem to love getting tattoos. Some people believe tattoos allow them to feel like individuals. Other people believe tattoos are a way for them to connect with their teams. What do you think about this? Why do you think soldiers and sailors get tattoos?

SEE A DIFFERENT SIDE! Tattoo artists feel they're creating art. They are different from other artists. They can't sign their names on their creations. They feel people should ask permission to post tattoo pictures online. Some people feel tattoo artists are doing a job. They get paid for a service. What do you think of both perspectives? Which perspective do you agree with more?

LEARN MORE

PRIMARY SOURCES

Tattoo, a documentary; episode 5 from Taboo series (National Geographic, 2004).
Tattoo Odyssey, a documentary (Smithsonian Channel, 2010).

SECONDARY SOURCES

Gordon, Stephen G. *Expressing the Inner Wild: Tattoos, Piercings, Jewelry, and Other Body Art.*
 Minneapolis: Twenty-First Century Books, 2014.
Mason, Paul. *Body Piercing and Tattoos.* Chicago: Heinemann Library, 2003.

WEB SITES

Association of Professional Tattoo Artists: www.professionaltattooartists.org
National Tattoo Association: www.nationaltattooassociation.com
Tattoo Artists Guild: www.tattooartistsguild.com

GLOSSARY

circuses (SUR-kuhs-ez) traveling shows

clients (KLYE-uhnts) customers, people who get tattoos

graffiti (gruh-FEE-tee) type of art scribbled on public places

mummy (MUHM-ee) a body that has been preserved

permanent (PUR-muh-nuhnt) long lasting, forever, doesn't go away

pigment (PIG-muhnt) color

portraits (POR-trits) drawings of faces

ports (PORTS) places near water where ships stop

preserved (prih-ZURVD) saved

studios (STOO-dee-ohz) tattoo shops

tattoos (ta-TOOZ) permanent designs on skin

INDEX

ABOUT THE AUTHOR

Dr. Virginia Loh-Hagan is an author, university professor, former classroom teacher, and curriculum designer. If she got a tattoo, it would have something to do with pianos. She lives in San Diego with her very tall husband and very naughty dogs. To learn more about her, visit www.virginialoh.com.